Hand Painted
Rustic Cards

Ruth Watkins

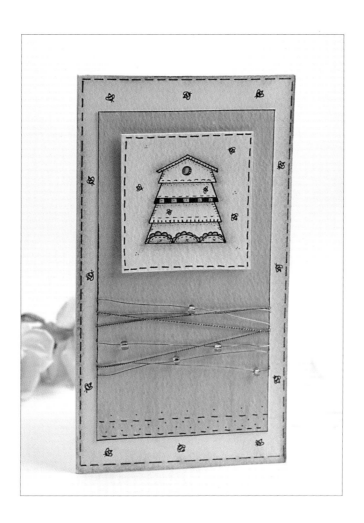

SEARCH PRESS

First published in Great Britain 2008

Search Press Limited
Wellwood, North Farm Road,
Tunbridge Wells, Kent TN2 3DR

Text copyright © Ruth Watkins 2008

Photographs by Roddy Paine Photographic Studio; and
Debbie Patterson, Search Press Studios

Photographs and design copyright © Search Press Ltd. 2008

ISBN: 978-1-84448-245-0

The Publishers and author can accept no responsibility for any
consequences arising from the information, advice or instructions
given in this publication.

Readers are permitted to reproduce any of the items in this book
for their personal use, or for the purposes of selling for charity, free
of charge and without the prior permission of the Publishers. Any
use of the items for commercial purposes is not permitted without
the prior permission of the Publishers.

Suppliers

If you have difficulty in obtaining any of the materials and
equipment mentioned in this book, then please visit the Search
Press website for details of suppliers: www.searchpress.com

Alternatively, you can contact the author direct at
www.wooden-it-be-lovely.com

Publisher's note

All the step-by-step photographs in this book feature
the author, Ruth Watkins, demonstrating how to paint
greetings cards. No models have been used.

No animals were harmed during the making of this book.

Printed in Malaysia.

Dedication

I dedicate this book to my husband and best friend, Andy,
whose consistent love, support and belief in me has never
wavered, and to my wonderful children, Emily and Will, who
have not complained when dinner has been late! Also to all
my fantastic students, who keep me motivated and bring so
much fun and happiness to my life.

Acknowledgements

A special thank you to my editor, Katie Sparkes, for her
expert help and for making the writing of my first book such
an enjoyable experience; to Gavin Sawyer for the wonderful
photography and bad chicken jokes; to Juan Hayward for
his artistic direction of the styled shots, and especially for
providing the baby quails; to the team at Craft Creations
for supplying all the fabulous card stock; to Auscraft for
providing the Jo Sonja paints which were a joy to use; to
Gluedots UK for the various adhesive products featured; and
last but not least to Roz Dace for giving me the opportunity
to produce my first book.

Cover: Speckled Hens
See page 38.

Page 1: Beehive card
*The beehive panel is cut out and mounted with 3D foam pads
on to a pale blue background. Strands of copper and coloured
wire are threaded with tiny beads and wrapped around the
lower section. This is then mounted on to a watercolour paper
card blank which is decorated with little bees and stitching.
You will find the template for this card on page 47.*

Contents

Introduction

Welcome to Hand Painted Rustic Cards. I am really excited to be given the opportunity to share my love of painting and card making with you in this, my first book. I have always loved creating things right from the time I was a little girl, although I took the scenic route to making my passion my career!

I hope that you enjoy making these cards and get as much pleasure sending them as I did from designing them. A lot of the cards feature elements found in the countryside such as sheep, hens and a farmyard cat; butterflies, birds and flowers; rosy red apples; and colourful bunting reminiscent of a village fête. The secret to achieving the fresh country look is to build gentle washes of colour and then enhance with a waterproof pen.

I love bringing each card to life by adding the finishing touches such as stitching and little patchwork hearts – this is definitely my favourite part! The pen is also a great way to cover up any mistakes (or happy accidents, as I call them) by adding a few extra stitches here and there or the odd bumble bee.

Luckily, free-hand drawing skills are not necessary as I have included easy-to-trace templates. Also incorporated are cards which utilise some fun extras from your craft box, such as decorative wire and tiny wooden pegs. I find that personalising your cards makes them extra special, and it is a good way of using up some of those embellishments that have been waiting for the opportunity to make your greetings cards shine.

Happy painting!

Ruth Watkins

Opposite:
A selection of greetings cards
you can make using this book.

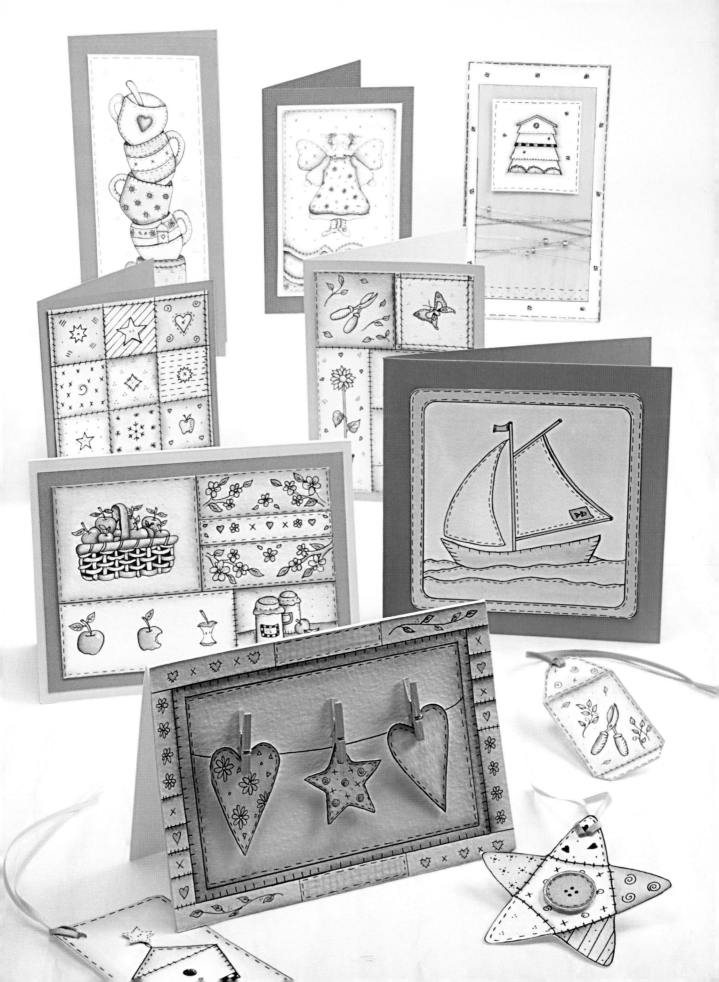

Materials

To create these lovely rustic cards you need only some basic supplies: a waterproof pen, a pencil, watercolour paper, card, tracing paper, a craft knife, adhesive, paper towel, a straight edge, a hairdryer, paints and paintbrushes. There are extra items included in the projects that you can purchase or may already have. These are fun to use and offer you greater variety in the cards you can make, but they are not essential and can gradually be added to your basic kit as your card making progresses.

Papers and cards

I favour 300gsm (140lb) white NOT watercolour paper to paint on, as it is strong enough to use as a card on its own without being mounted. It also tends not to curl when wet. You can purchase it as ready-made card blanks or as a pad.

Sometimes I like to trim and mount my designs on to coloured card. I find a pack that contains A4 sheets in many different shades and colours is really useful, as I can usually find at least one that complements my design. If you prefer not to make your own cards, you can opt for ready-made ones which come in numerous styles, sizes and colours. Experiment with different-shaped aperture cards, as sometimes a design can work well in an oval aperture, for example, and not so well in a square one. When you mount your picture, remember you can always trim the card with a craft knife to fit if necessary.

If you are on a budget, buy white envelopes as they will go with all your cards. Alternatively, if cost is not a problem, stock up on a range of coloured envelopes for a more coordinated look.

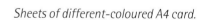

Sheets of different-coloured A4 card.

A range of ready-made plain and aperture card blanks.

Pens and pencils

For outlining your images, and for adding stitching and extra details, you will need a fine-tipped pen that is labelled 'waterproof' or 'permanent'. All good stationers and art shops should stock them in a range of different sizes and colours. I have used black, brown and blue for the projects in this book. For the majority of cards, I mainly use a size 02, swapping to a 01 for fine detail or for stitching. To add bolder strokes, I favour a 03 or a 05. If you wish to purchase just one pen at first, I would suggest a black 02 would be a good choice.

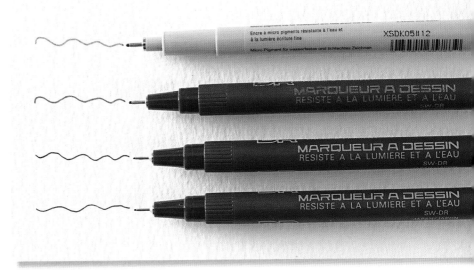

Various pens showing different colours of ink and width of ink line.

Brushes

Good brushes, which hold a lot of paint without flooding the paper, are essential for good results. I like to use a selection of different-sized round brushes that have good points. I use the largest brush that I feel comfortable with for any given area, so I do not have to keep reloading it with paint too often. For adding the shading, my preferred brush is an angular shading brush as it blends the paint well, giving a graduated effect which adds depth to your painting. Sizes 2 and 4 round brushes, and a 0.5cm (¼in) angular shader would be ideal first purchases.

Tip

When you have finished your painting, wash your brushes in warm, soapy water, reshape the bristles and leave them to dry flat on a piece of paper towel.

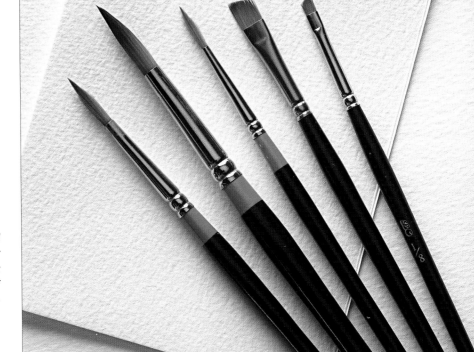

A selection of different-sized round brushes and angular shading brushes, laying on the white, textured watercolour paper I use for my paintings.

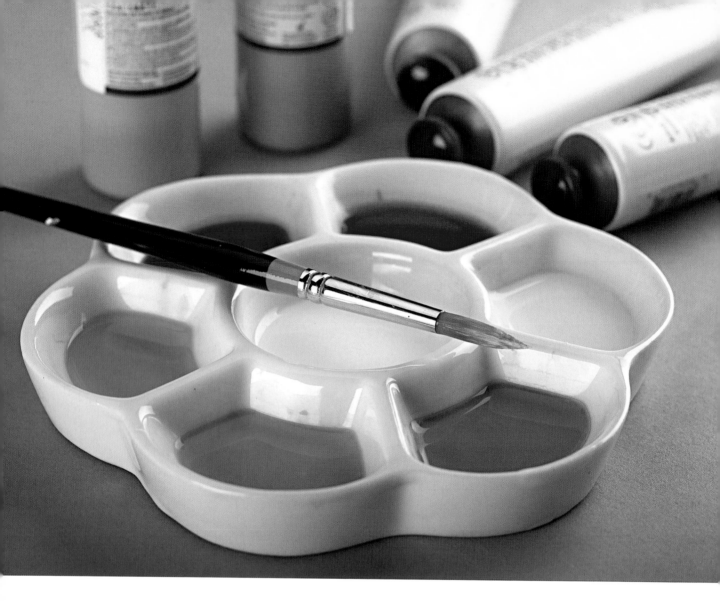

Paints

I use artist-quality, acrylic paints in tubes and bottles. To create the projects in this book, I used a basic palette of pale yellow, mid-brown, cream, blue, green, turquoise and burgundy red. I also used black in the project on pages 17–19. These colours can be made stronger or weaker by adding more or less water to achieve a wide range of shades. I add the water to the paints with a pipette, but you can also use a large, clean paintbrush.

I like to use a ceramic daisy dish which is divided into individual sections to hold the different colours. Alternatively, you could space out your washes on a ceramic tile or other non-porous surface.

Other materials and equipment

A **brush basin** makes a very practical water container and is excellent for washing out your brushes between colours. It is also very stable and so helps avoid spillages. A small **plastic ruler** is useful for drawing straight lines with the pen. I use it upside-down so that it is raised off the surface, which helps to avoid smudges. I also use a long **metal ruler** as a straight edge to guide my **craft knife** along when trimming card. These are best used in conjunction with a **cutting mat** to protect your work surface. A selection of **scissors** can be used to cut out smaller shapes. To heat-set the ink before applying paint, I always use a small **hairdryer** on the highest setting, and a **pipette** is useful for adding water to my paint mixes, though a large paintbrush would do just as well.

Plastic templates, such as the different-sized squares shown below, make light work of drawing certain shapes. Alternatively, you can use a ruler.

Paper towel is handy to absorb excess paint from the tips of brushes prior to painting. I like to fold mine up into quarters and use each piece time and time again – just keep it to one side and leave to dry out! **Tracing paper** is necessary to trace the designs from the templates printed in the book. Kitchen greaseproof paper works well too, but not the unbleached type, as it is not transparent. I use wax-free or water-soluble **transfer paper** to transfer my designs with either a **stylus** or an empty **ballpoint pen**. An **eraser** may be needed to remove unwanted marks prior to painting. I have used **double-sided sticky tape** or **glue stick** to assemble the cards, and **glue dots** or **3D foam pads** to stick on the embellishments.

Some of the projects in this book call for more specialist equipment such as an **embossing pen**, **embossing powder** and a **heat gun**. Special effects can be created with a **speckling tool** and with **masking fluid**. I have also used some **paper punches**, **miniature pegs**, **gold wire**, **beads** and **adhesive crystals** to enhance some of the cards.

Tip

You can make your own transfer paper by taking a piece of tracing paper and rubbing graphite pencil over one side of it. Slip this under your design and go over the lines with a stylus or empty ballpoint pen (see page 12).

A selection of the various materials and pieces of equipment you need to make the cards in this book.

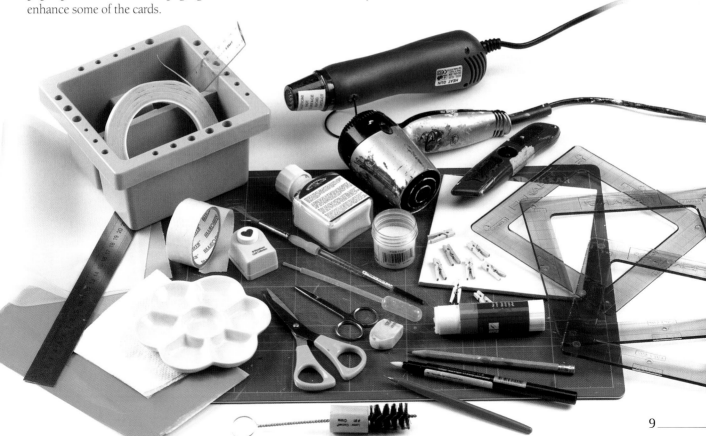

Basic techniques

This classic sailing-boat card is the perfect project for you to begin with, allowing you to master all the basic techniques you will need to create the beautiful cards featured in the rest of this book. The method of painting I use is a traditional one, sometimes known as the 'pen and wash' technique. To achieve the desired effect, I have applied the technique to my own, contemporary designs and added mock stitching to give them a soft, rustic feel.

Subtle blending, rather than harsh bands of colour, is the key to obtaining a good result, so when you are painting remember to use diluted paint and to build up the required intensity of colour with layers rather than one thick coat of paint.

YOU WILL NEED

Acrylic paints: burgundy red, cream, pale yellow, green, blue, turquoise and mid-brown

Sizes 4 and 8 round brushes with very fine points

Sizes 01, 02 and 03 permanent black waterproof pens with fine tips

Watercolour paper, 12 x 12cm (4¾ x 4¾in)

Green card blank, 14.5 x 14.5cm (5¾ x 5¾in)

Copy of template

Tracing paper

Non-waxed or water-soluble transfer paper

Stylus or empty ballpoint pen

Daisy dish or ceramic tile

Spare piece of watercolour paper (for testing strengths of colours)

Pipette

Paper towel

Brush basin

Plastic ruler

Hairdryer

Craft knife

Cutting mat

Scissors

Metal ruler

Double-sided sticky tape

Square border template (optional)

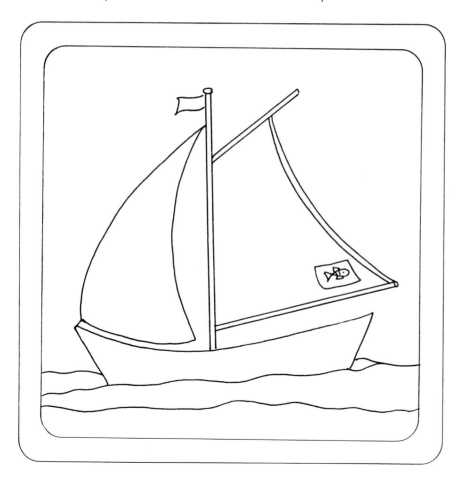

Full-size template.

Mixing your colours

1 Decide which colours you wish to use, and place a small amount of each on your daisy dish or ceramic tile.

2 Using a pipette, add water to each one in the ratio of approximately eight parts water to one part paint. (You may use a large paintbrush to do this if you do not have a pipette.)

3 Mix the paint and water together using a paintbrush. Stir well to dissolve all the pigment. The paint should assume an ink-like consistency.

4 Test each colour on a spare piece of watercolour paper, if necessary adding more water to achieve a pale, translucent tone. Ensure you remove all traces of paint from your brush in between colours to avoid cross-contamination.

Tip

Use a brush basin for your water if possible. It allows you to clean your brush thoroughly by simply rubbing it firmly over the ridged base.

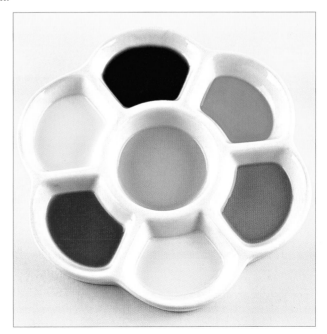

The final colour palette.

Transferring the design and drawing the outline

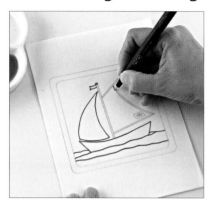

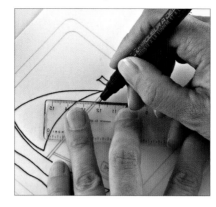

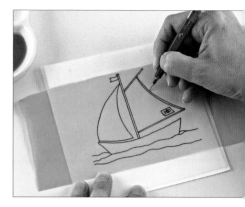

1 Trace over a copy of the template using either a size 2 or a size 3 permanent black waterproof pen with a fine tip.

2 Use a plastic ruler to draw in any straight lines. Use the ruler upside-down so that you can lift it off easily without smudging.

3 Transfer the image to your watercolour paper. First ensure the image is correctly positioned, then lay a sheet of transfer paper underneath it, ensuring it is the right way up. Go over the lines using a stylus or empty ballpoint pen, again using a ruler where necessary. Do not press too hard, otherwise you may dent the watercolour paper.

4 Remove the transfer paper to reveal the image on the watercolour paper underneath.

5 Using the same pen, draw over the outline on the watercolour paper. (It does not matter if any of the transfer lines still show, as they will dissolve when you apply the paint or can be removed with an eraser.)

Tip

The ink must be set for approximately one minute, as shown in step 7, each time it is applied prior to washes being used. The washes must also be dried in the same way before more ink is added.

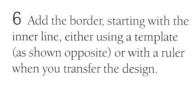

6 Add the border, starting with the inner line, either using a template (as shown opposite) or with a ruler when you transfer the design.

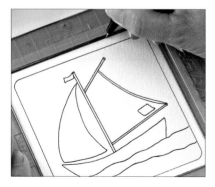

7 Dry the ink using a hairdryer, held approximately 2cm (¾in) away from the paper. If the paper begins to curl, turn it over and heat the back – this will help flatten it.

Painting

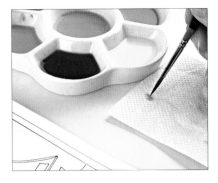

1 Starting with the sea, stir the blue paint with a size 4 round brush and dab off the excess on a piece of paper towel to avoid flooding.

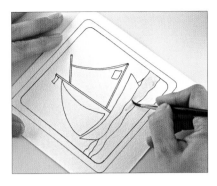

2 Paint an even wash of colour over the blue area of the sea.

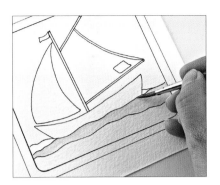

3 While the paint is still wet, lay another thin line of blue along the top of the blue area and allow it to spread downwards into the first layer of paint to obtain a graduated wash. Keep adding thin washes in this way until you achieve the desired intensity of colour.

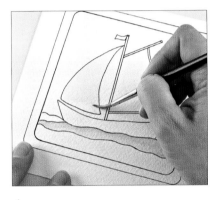

4 Move to a different area that is not adjacent to the first, in this case the headsail. Clean the brush thoroughly (see page 11), load the brush as before with pale yellow paint, and apply a thin, even base coat.

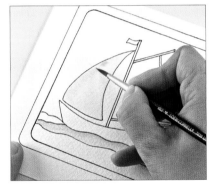

5 While the paint is still wet, clean the brush and pick up a little burgundy red. Add a line of colour down the front of the sail, starting a little way in from the edge and allowing the paint to blend naturally with the yellow.

Tip

The technique of adding wet paint to a wet background wash and allowing them to blend on the paper is known as wet on wet.

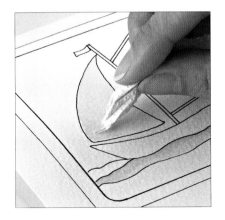

6 If you accidentally apply too much paint, soak it up using the tip of a screwed-up piece of paper towel.

7 Paint the mainsail in the same way, taking the burgundy red down the left-hand side and around the top.

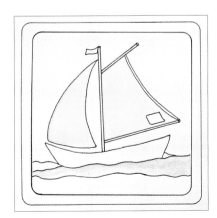

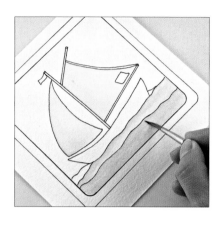

8 For the green wave, apply a wash of blue as before, then clean your brush and apply a wash of green over the top. Apply the green just below the top edge of the wave, then push it up to the line. This avoids the colour accidentally spreading across the line into the area above.

9 Paint the two green waves either side of the boat to complete the sea.

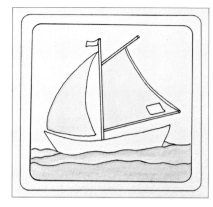

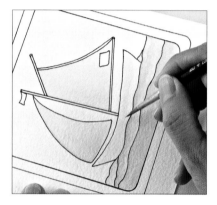

10 Paint the hull using a wash of pale yellow followed by a wash of mid-brown, applied in the same way as the blue and the green wash in step 8.

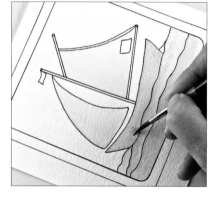

11 Add a little burgundy red around the edges, allowing it to blend naturally into the background wash.

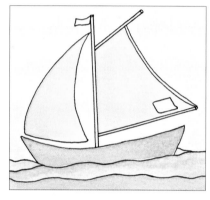

The completed hull.

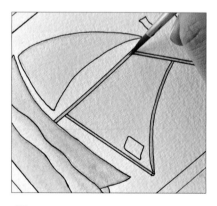

12 Paint in the mast and the border round the mainsail in mid-brown, then go around their outer edges in burgundy red using the tip of the brush.

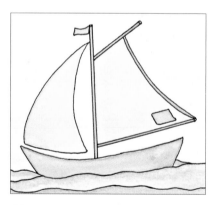

13 Build up the colour, then paint in the flag and the patch on the mainsail in burgundy red.

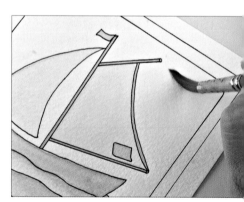

14 For any large areas, in this case the sky, wet first using a size 8 brush. This helps to give a smooth look without any hard edges. Avoid over-wetting, and take the water as close as possible to the edge of the main image without crossing the outline.

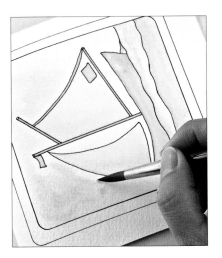

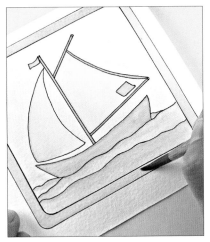

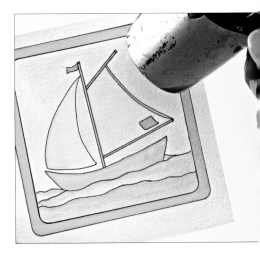

15 Load the brush with blue paint and work the paint into the background. Apply the paint randomly to obtain a mottled effect that resembles clouds. Take the paint right up to the edge of the image. Build up the colour in layers until you achieve the desired tone.

16 Paint the border in the same way, wetting it first with clean water and then applying burgundy red paint.

17 Strengthen the colours where necessary, then dry the finished painting well with a hairdryer and allow it to cool.

Tip

As a general rule, always apply a pale, fairly watery wash of paint to an area first and then build up the colour by adding further washes. This will allow you to create subtle variations in tone. Either use the wet-on-wet method or allow each layer to dry thoroughly before applying the next. Avoid adding further washes if the paint is only partially dry as this will lead to streaking.

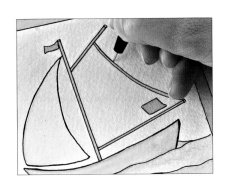

18 Go over any lines that look too faint with a fine, size 1 pen.

Tip

Always use a smaller pen when touching up any lines to avoid it looking too heavy.

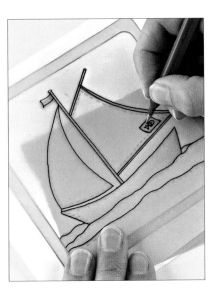

19 Transfer any extra detailing, in this case the design on the mainsail, and draw over it with the fine-nibbed pen.

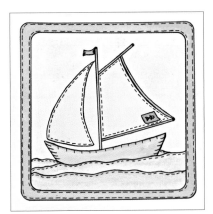

20 Add the stitching using the fine-nibbed pen. This is best done free-hand, without a ruler, to achieve a more natural-looking finish. Try to make the stitches as even as possible, and rest your hand on the work surface for greater control.

Mounting your painting on to a card

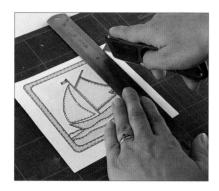

1 Place your design on to a cutting mat, line up the ruler down one side so that it is just touching the black outline, and draw the craft knife firmly along the edge of the ruler. Use scissors to round off the corners.

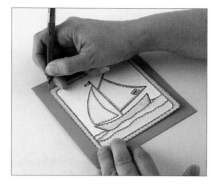

2 Centre the image on the front of the green card blank, and mark the card at each corner using the tip of a stylus.

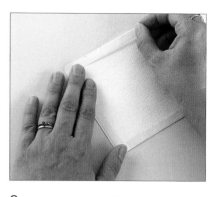

3 Cut four strips of double-sided sticky tape and attach them to the back of the image, one along each side.

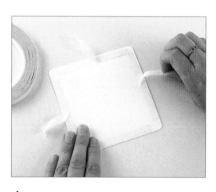

4 Peel back the protective layer halfway along each strip and fold it outwards at 90°.

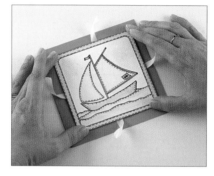

5 Lay the picture on the front of the card blank, aligning it with the marks you made earlier (see step 2).

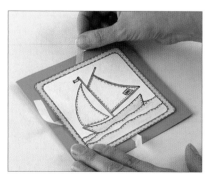

6 When you are satisfied that the image is positioned correctly, press down on it firmly and pull out the tabs.

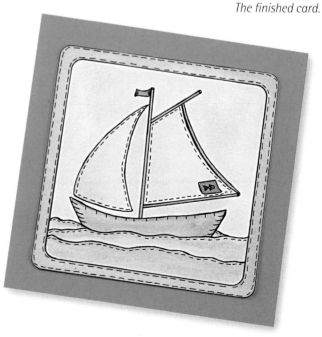

The finished card.

Advanced techniques

Three friendly sheep standing on a hillside star in this card, which shows you how shading with an angular shading brush can add real depth and form to your cards. Begin by mixing up the colours, transfer your design following the basic method explained on page 12, and you will soon have your very own flock of sheep!

YOU WILL NEED

Acrylic paints: burgundy red, cream, green, blue, mid-brown and black

Sizes 2, 4 and 8 round brushes with very fine points

0.5cm (¼in) and 0.25cm (⅛in) angular shading brushes

Sizes 01, 02 and 03 permanent black waterproof pens with fine tips

Watercolour paper, 21 x 10cm (8¼ x 4in)

Cream card blank, 11 x 22cm (4¼ x 8½in)

Copy of template

Tracing paper

Non-waxed or water-soluble transfer paper

Stylus or empty ballpoint pen

Daisy dish or ceramic tile

Spare piece of watercolour paper (for testing strengths of colours)

Pipette

Paper towel

Brush basin

Hairdryer

Craft knife

Cutting mat

Metal ruler

Double-sided sticky tape

Non-porous tile or china plate

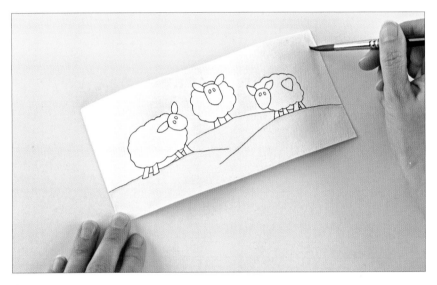

1 Wet the paper first, then using a size 8 brush, paint in the sky and the ground using washes of blue and green respectively. Allow the paint to dry.

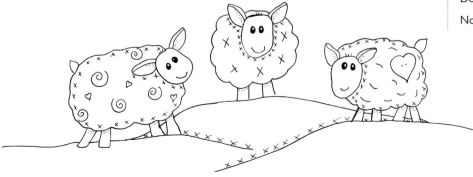

Template, two-thirds actual size. To enlarge to the correct size, increase by fifty per cent.

Floating colour

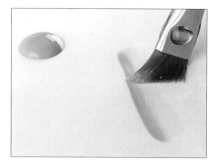

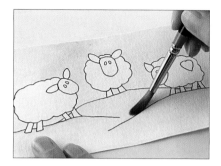

1 Put a small drop of undiluted green paint on to a non-porous tile or china plate. Dampen an angular shading brush, dab it once on a piece paper towel and pick up a small amount of paint using the 'long' corner of the brush. This is known as 'side loading'.

2 Work the brush back and forth across the tile several times to create a single, stroked line approximately 2cm (¾in) long. The paint should blend with the water to produce a gradual transition from dark, full-strength colour on one edge of the stroke to clear water on the other edge.

3 Wet the area where you wish to lay the float of colour using a size 8 brush; in this case, just behind the hills. (This is indicated by rows of small crosses on the template.)

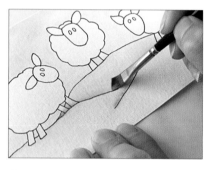

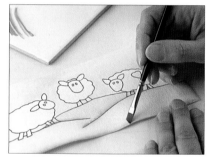

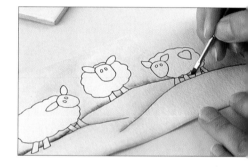

4 Blend the colour picked up on the angular brush across the area you wish to shade, so that the darker edge of the paint lies closest to the outline. Apply the paint evenly, using the whole of the angled edge of the brush.

5 Repeat around the sides and base of the area of grass.

6 Apply colour behind the sheep and the edges of the sky in the same way using blue to give the picture a border.

Tip

As a general rule, use a 0.5cm (¼in) angular shading brush for larger areas and a 0.25cm (⅛in) brush for small areas.

7 Paint the sheep using a size 4 brush with washes of cream for the bodies and burgundy red for the heart, and a light wash of black for the faces and legs. When the paint is dry, outline the sheep's bodies with a float of mid-brown and place a float of burgundy red around one side of the heart, following the method described above.

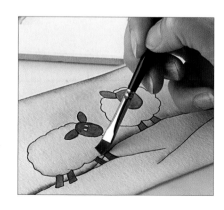

Applying patterns and details

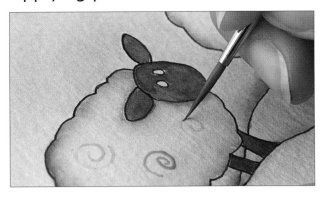

1 Using a size 2 round brush, paint the spiral patterns on the sheep's bodies using the very tip of the brush and a light touch. Hold the brush upright as you work, and make sure the background on which you are painting is completely dry.

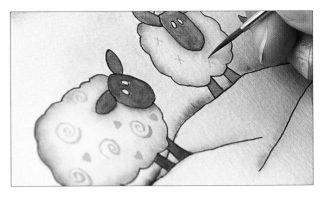

2 Paint on the hearts and crosses in the same way.

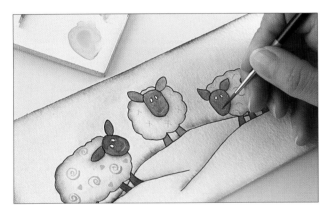

3 Paint the shapes on the third sheep, then add the mouths using a mix of burgundy red and cream to create pink. Dry well with a hairdryer.

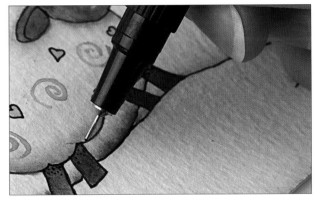

4 Outline the hearts, and draw in the rest of the detailing using a size 1 permanent black waterproof pen: the stitching; the grass; the sheep's eyes; the three-dot patterns in the sky; and add tiny dots in the shadows at the tops of the legs and in the ears.

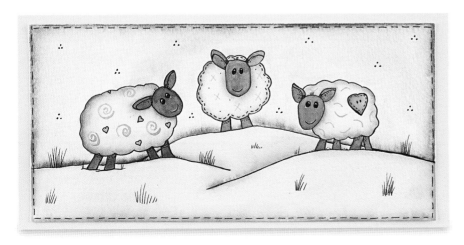

The finished card.

Tip

In this design, I have drawn each stitch on the middle sheep as a curved rather than a straight line. This gives a 'looser' feel to the stitching.

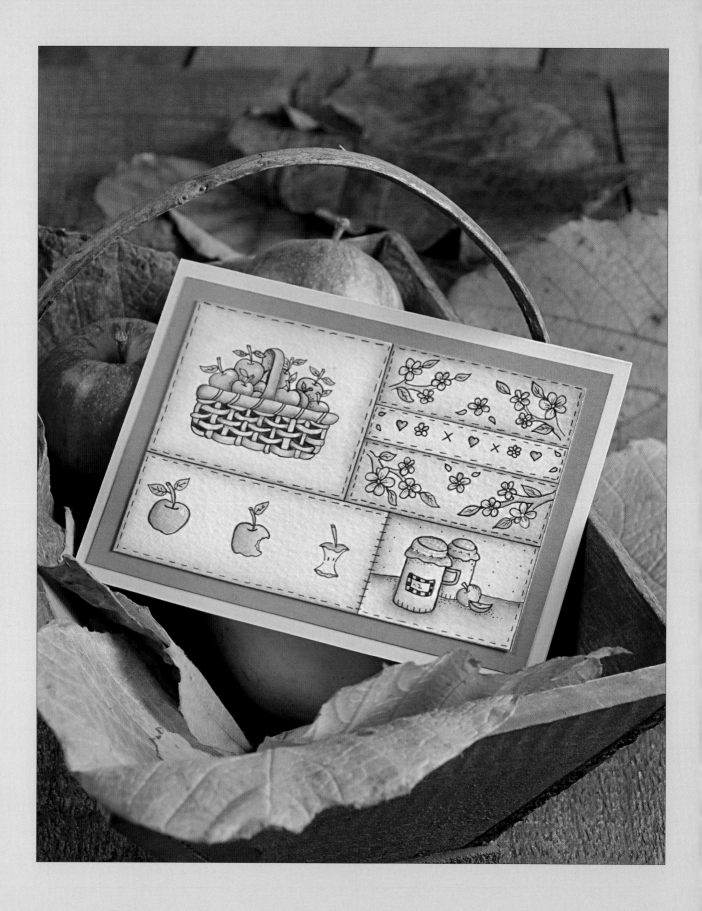

Patchwork Apples

I love the beautiful rustic tones used to paint these apples. They look so realistic, you can almost taste them! It is great fun adding all the stitching to the panels and there are more ideas for patchwork-themed cards at the end of this section. Remember, if you need to refresh your memory of any of the techniques, simply refer back to the two cards on pages 10–19 for step-by-step guidance.

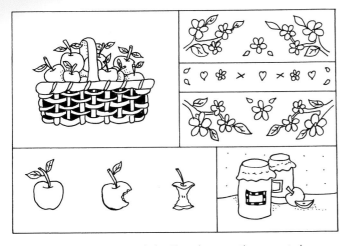

Template, two-thirds actual size. To enlarge to the correct size, increase by fifty per cent.

You will need

Acrylic paints: burgundy red, cream, pale yellow, green, blue and mid-brown

Sizes 2 and 4 round brushes with very fine points

0.5cm (¼in) and 0.25cm (⅛in) angular shading brushes

Sizes 01 and 02 permanent black waterproof pens with fine tips

Watercolour paper, 14.5 x 10cm (5¾ x 4in)

Dark pink card, 14.5 x 10cm (5¾ x 4in)

Light pink card blank, 11 x 16cm (4¼ x 6¼in)

Copy of template and tracing paper

Non-waxed or water-soluble transfer paper and stylus

Daisy dish or ceramic tile, brush basin and pipette

Spare piece of watercolour paper

Paper towel

Plastic ruler and metal ruler

Hairdryer

Cutting mat and craft knife

Double-sided sticky tape

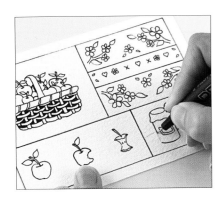

1 Transfer the design to a piece of watercolour paper measuring 14.5 x 10cm (5¾ x 4in). Use a fine-pointed size 02 black pen and set the ink with a hairdryer.

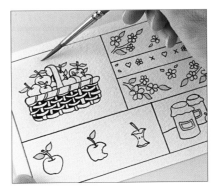

2 Mix up your colours and begin by laying in the green backgrounds and the leaves, starting with the leaves. Use the tip of a size 4 round brush. Dry the paint with a hairdryer.

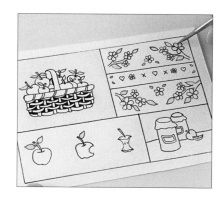

3 Paint the cream backgrounds in the lower left-hand panel and the hearts-and-flowers panel, then paint in the jam jars, apple core and blossoms using the same colour. Dry the paint with a hairdryer.

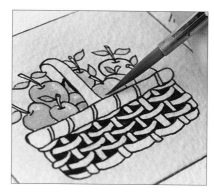

4 Put in the red on the apples in the basket, applying a fairly watery wash first and then adding further washes to build up the colour in the darker areas. Leave tiny bare patches for the highlights.

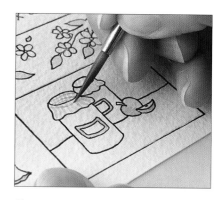

5 Paint the remaining small areas of red in the same way, and paint in the gingham stripes on the jam jar lids using the tip of the brush.

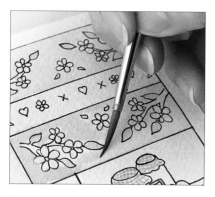

6 Dampen the backgrounds in the red panels and apply a pale wash of burgundy red. Build up the colour to the desired level with further washes.

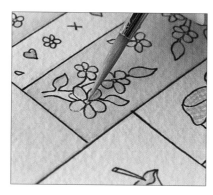

7 Continuing with the burgundy red, paint in the hearts, then wet the flower petals and place a dot of colour on their tips. Change to yellow, and paint in the centres of the flowers.

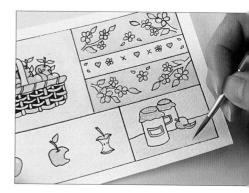

8 Carefully paint the weave and handle of the basket using mid-brown (avoid painting over the black lines). With the same colour, paint in the blossom branches and apple stalks, and lay a light wash of colour on the table in the jam jars panel.

9 Mix a little green and blue together on a tile to create a darker green and strengthen the colour on the lower halves of the leaves. All the background washes are now in place. Dry with a hairdryer.

10 Start to deepen the tones by floating in colour. Beginning with the apples in the basket, use a small angular shading brush to place in the shadows using full-strength paint.

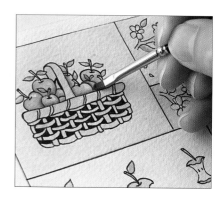

11 Use the same method to deepen the shadows down the left-hand sides of the three apples in a row, then change to the larger angular shading brush and frame the two red panels and the cream panel containing the hearts.

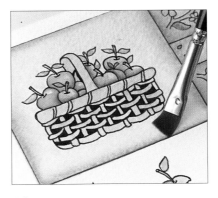

12 In the same way, float green around the edge of the green panel, top left.

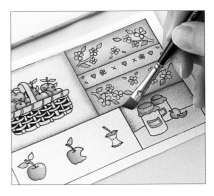

13 For the lower right-hand panel, use a darker mix of green by adding a little blue to the green on the tile.

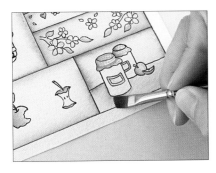

14 Float in a wash of mid-brown around the lower left-hand panel and across the top part of the table in the lower right-hand panel, carefully taking the paint around the jam jars and apples.

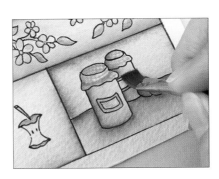

15 Lay a gentle float of mid-brown down the left-hand sides of the jars. When the paint has dried, lay a float of burgundy red over the brown placed across the top part of the table.

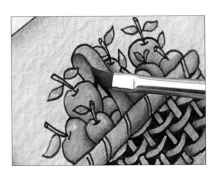

16 Change back to the small angular shading brush and add shadows to the weave of the basket using mid-brown, and down the inside of the handle and along the lower edge of the rim using a burgundy red and mid-brown mix. Dry with a hairdryer.

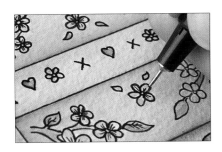

17 Using a fine, size 1 pen, add the detailing on the leaves, flowers and jam jars, and the stitching. Strengthen any black lines that require it.

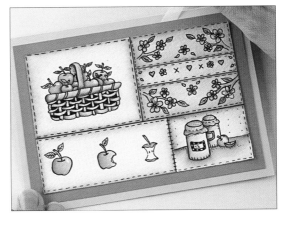

18 Trim round the picture with a craft knife and ruler on a cutting mat. Mount the painting on to the dark pink card, and then on to the pale pink card blank (see page 16).

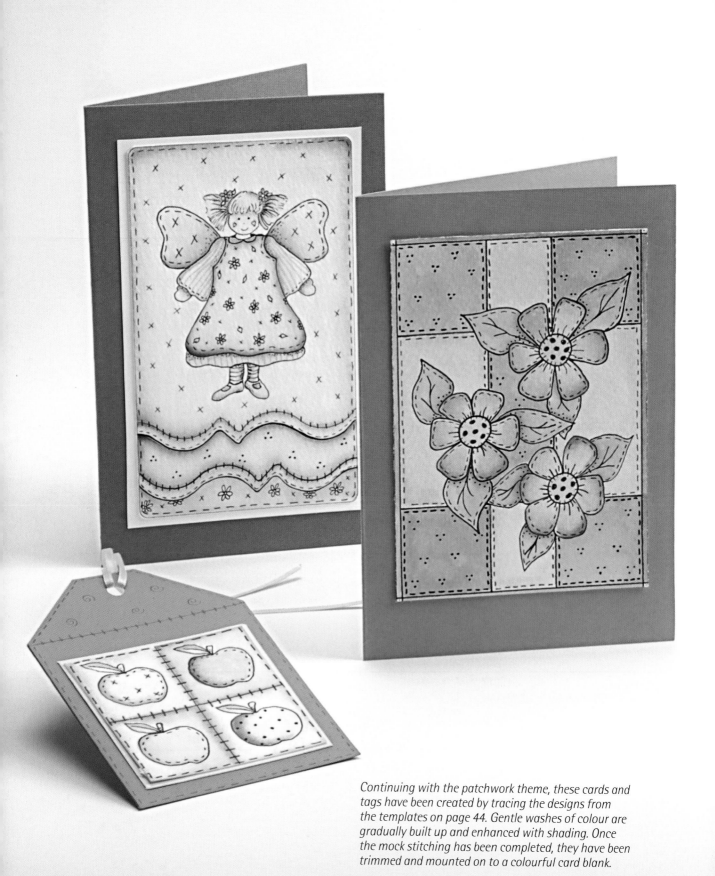

Continuing with the patchwork theme, these cards and tags have been created by tracing the designs from the templates on page 44. Gentle washes of colour are gradually built up and enhanced with shading. Once the mock stitching has been completed, they have been trimmed and mounted on to a colourful card blank.

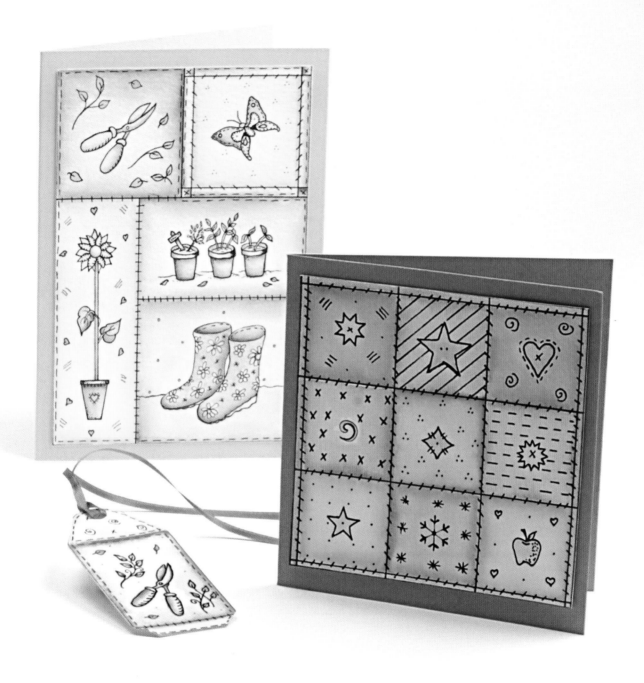

Here individual pictures with a similar theme or style have been grouped together, and then linked with stitching detail giving a fun and coordinated look. For the matching gift tag just one element has been painted on to a piece of watercolour paper. This has then been trimmed into a tag shape and some ribbon threaded through a small hole created with a hole punch.

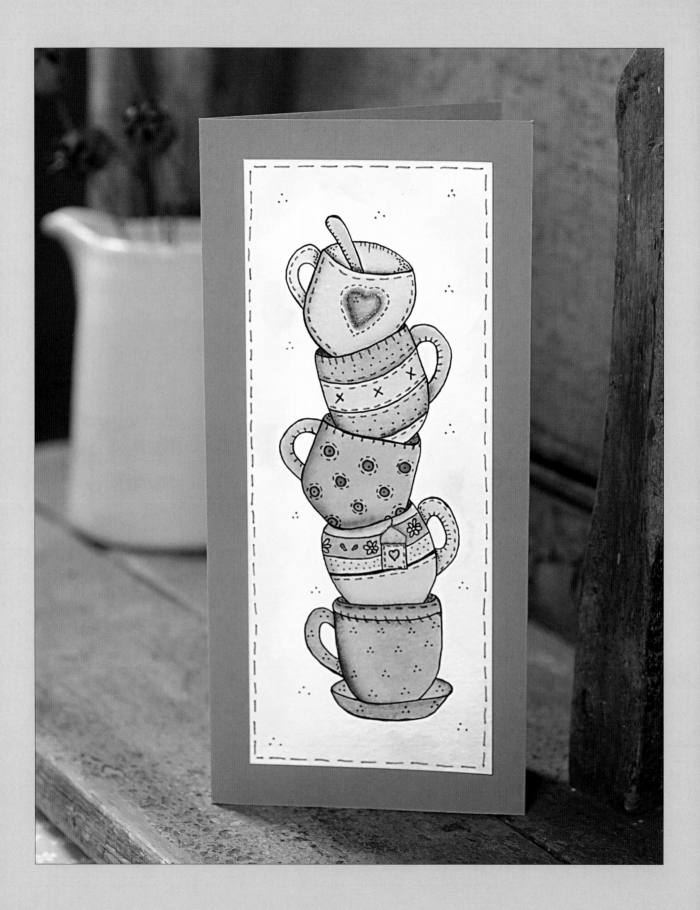

Cups and Saucers

One of my favourite pastimes is sharing a cup tea with friends, so I just had to include this card featuring a stack of old-fashioned cups and saucers! This project uses a soft palette limited to just six colours, and for added dimension I have used an embossing pen, embossing powder and a heat gun to add gold accents on the heart motif and teabag label. So put the kettle on and let's get painting!

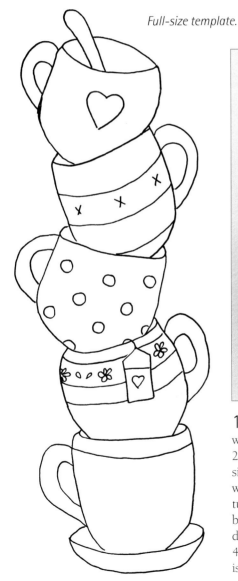

Full-size template.

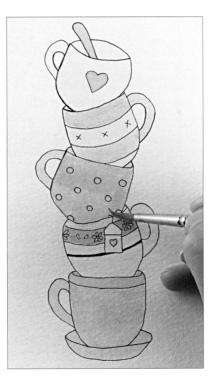

YOU WILL NEED

Acrylic paints: burgundy red, cream, pale yellow, blue, turquoise and mid-brown

Sizes 2, 4 and 8 round brushes with very fine points

0.5cm (¼in) and 0.25cm (⅛in) angular shading brushes

Size 05 brown and sizes 01 and 02 black permanent waterproof pens

Watercolour paper, 10 x 20cm (4 x 8in)

Blue card blank, 10 x 20.5cm (4 x 8¼in)

Fine-tipped, clear embossing pen, gold embossing powder and heat gun

Copy of template and tracing paper

Non-waxed or water-soluble transfer paper and stylus

Daisy dish or ceramic tile, brush basin and pipette

Spare piece of watercolour paper and A4 sheet of printer paper

Paper towel

Hairdryer

Cutting mat and craft knife

Metal ruler and set square (optional)

Double-sided sticky tape

1 Transfer the design to a piece of watercolour paper measuring 10 x 20cm (4 x 8in) using a fine-pointed size 02 black ink pen. Set the ink with a hairdryer. Add the yellow, blue, turquoise, burgundy red and mid-brown background washes, without dampening the paper first, using a size 4 round brush. Make sure each colour is dry before applying the next.

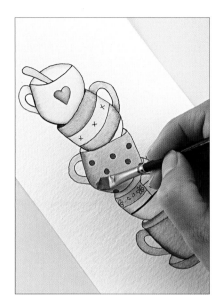
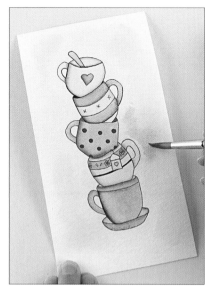
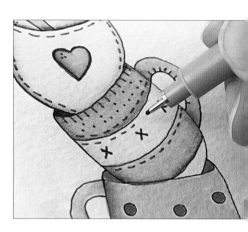

2 Float in colour to create shadows down the left-hand sides and around the tops of the cups, and anywhere else a shadow might fall. Use full-strength paint of the same colour as the background wash on the turquoise and burgundy red cups, mid-brown on the yellow cups, and a mix of turquoise and blue on the turquoise cup.

3 Wet the white background, and use a large, size 8 brush to add random patches of diluted burgundy red, yellow and mid-brown paint. Soften each colour with a damp brush before moving on to the next, and allow the edges to blend naturally on the paper. Leave some areas white.

4 Dry the paint with a hairdryer, and add the detailing and stitching using a size 05 brown ink pen.

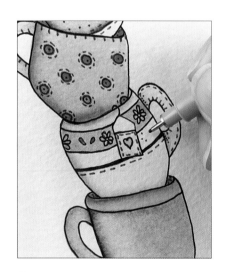
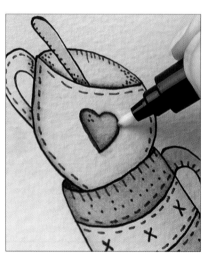
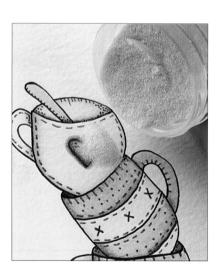

5 Outline the circles, flowers and leaves, then change to the size 01 black ink pen and strengthen the black outlines where necessary. Make sure the ink is completely dry before moving on to the next stage.

6 Working on a spare sheet of printer paper creased down the middle, draw around the heart using a fine-tipped, clear embossing pen.

7 Cover the heart in gold embossing powder, tipped straight from the pot.

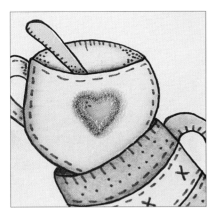

9 Emboss the top part of the tag in the same way, then set the powder using the heat gun. Hold the heat gun approximately 4cm (1½in) above the paper, and move it steadily from side to side to spread the heat evenly. Directly the powder has melted and become shiny, remove the heat.

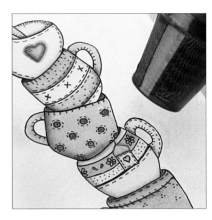

8 Tip the excess powder on to the A4 sheet and funnel it back into the pot, leaving a gold outline around the heart.

Tip

You may prefer to hold the paper with a clothes peg to stop your fingers from getting burnt!

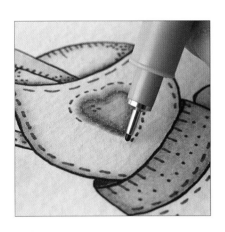

10 Draw on the stitching around the heart with the size 05 brown pen.

11 Place the image on a cutting mat, and trim the sides by running a craft knife along the edge of a metal ruler. Leave a border approximately 1cm (½in) wide each side, and 1.5cm (¾in) wide at the top and the bottom. If necessary, make sure the sides are straight using a set square.

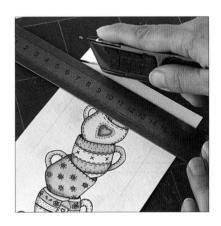

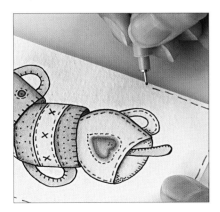

12 Add brown stitching around the outside of the picture, and little groups of three dots on the background.

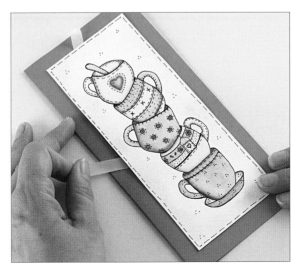

13 Mount the image on to the blue card blank.

Flowers and butterflies are popular designs as they can be used for all sorts of occasions such as birthdays and anniversaries as well as for thank-you cards. On the butterfly card silver embossing powder has been used to outline the design as well as on the stitching to give a really opulent look. The centres of the flowers and dragonflies on the green card have had gold applied to add interest and texture.

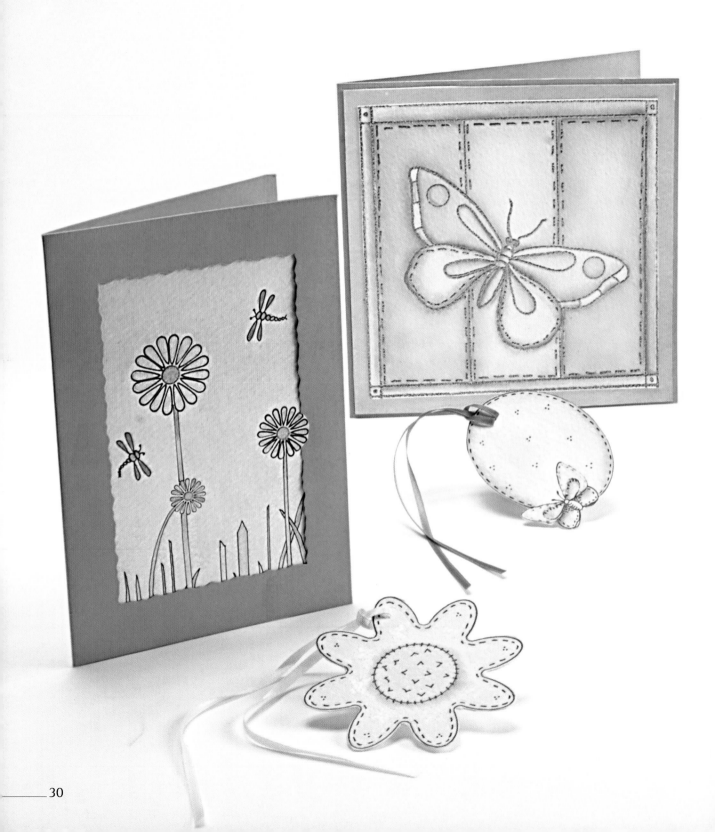

On the birthday-themed card, clever use of clear embossing powder enhances the design without being overpowering. Pick out small elements to emboss, such as the bow and the tiny heart on the letter, and once heated the powder will melt to give them a slightly raised and glossy appearance.

The little runaway train has gold embossing powder added to the centres of the wheels and would make a lovely greetings card for a child. The edges of the card have been softened with a round-corner paper punch and then the design has been mounted on to a card which is folded at the top instead of the side. You could use blue instead of pink for a different look.

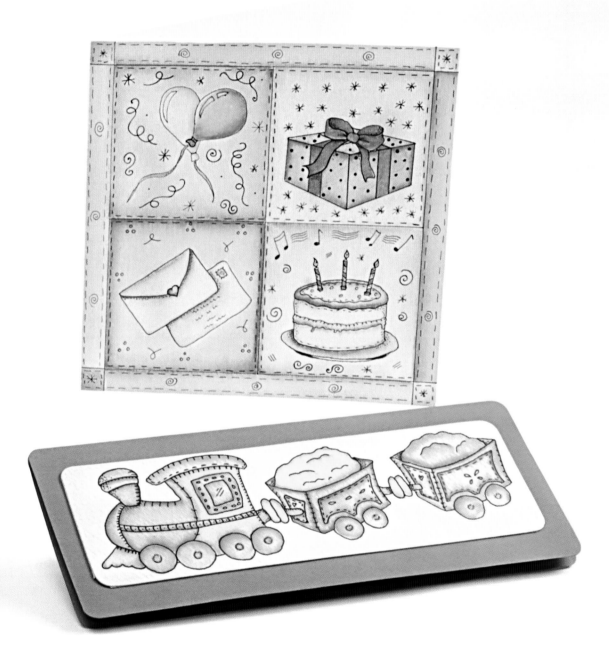

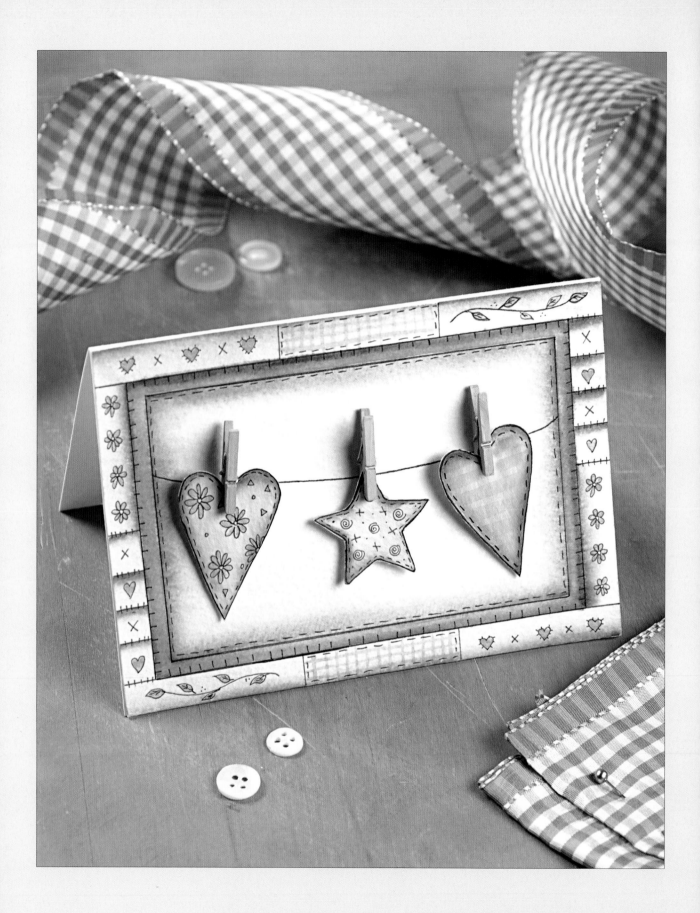

Blue Hearts

This card was inspired by trying to find a use for these cute wooden pegs. I incorporated hearts and stars motifs as these are another favourite of mine and are always popular. As you can see, this card is painted in different tones of just one colour for a stunning visual effect, and the cut-out elements are raised for added interest.

This card would work just as well using a different colour such as red or green, so do not be afraid to experiment! You could also write your own personal message on one of the hearts, such as 'Happy Birthday', to make your card extra special.

YOU WILL NEED

Blue acrylic paint

Sizes 2, 4 and 8 round brushes with very fine points

0.5cm (¼in) and 0.25cm (⅛in) angular shading brushes

Sizes 01 and 02 permanent black waterproof pens

Watercolour paper, 15 x 12cm (6 x 4¾in)

White card blank, 12 x 15cm (4¾ x 6in)

3D foam pads

3 blue-painted wooden craft pegs

Copy of template and tracing paper

Non-waxed or water-soluble transfer paper and stylus

Daisy dish, ceramic tile, brush basin and pipette

Spare piece of watercolour paper

Paper towel

Plastic ruler and metal ruler

Hairdryer

Cutting mat, craft knife and scissors

Double-sided sticky tape

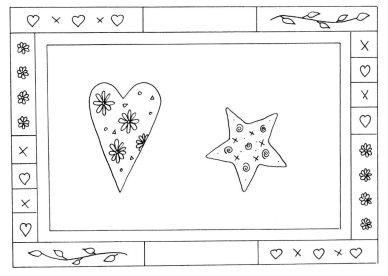

Templates for the frame, heart and star, two-thirds actual size. To enlarge to the correct size, increase them by fifty per cent.

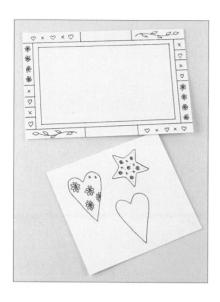

1 Begin by transferring the design for the frame on to a piece of watercolour paper measuring 15 x 12cm (6 x 4¾in), and the two hearts (one plain and one with the flower design) and the star on to a separate piece of watercolour paper. Dry the ink using a hairdryer for approximately one minute.

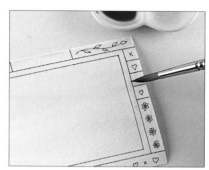

2 Wet the background, then apply an even blue wash using a large size 8 brush.

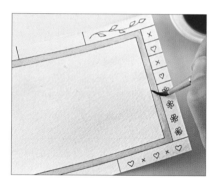

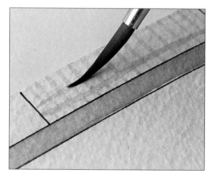

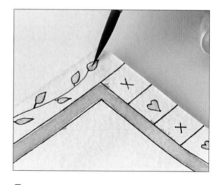

3 Darken the colour by adding more paint to the mix in the palette, then use a size 4 brush to deepen the inner border. Apply two or three washes to achieve the required tone.

4 Paint in the gingham pattern in the outer border using the tip of the brush.

5 Paint all of the hearts, flowers and leaves using two or three layers of colour. Dry the paint using a hairdryer.

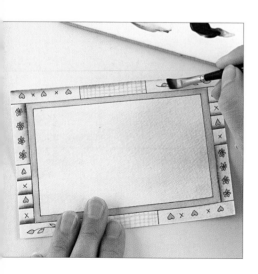

6 Re-wet the outer border and float in colour along the top and bottom of the paper, the inner edge of the flower panels, and the top edge of the small squares containing single hearts and crosses. Use a 0.5cm (¼in) angular shading brush and full-strength paint.

7 Float in colour around the inside of the frame, then dampen the inner border using a size 4 brush and run a thin line of colour along the outer edge, allowing the paint to blend naturally on the paper.

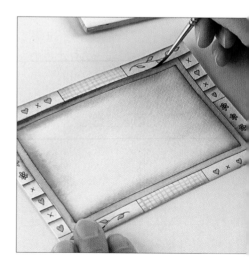

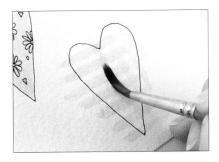

8 Lay a light background wash over the flower heart and star shape, then paint the gingham pattern over the plain heart, extending the stripes beyond the outline.

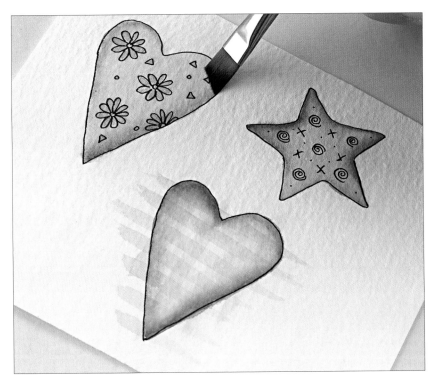

9 Paint in the flowers and hearts, then float colour around the outside of each shape.

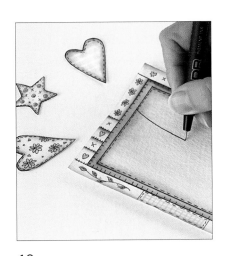

10 Dry the shapes with a hairdryer, strengthen the outlines, and add the stitching to both the shapes and the main design using the size 01 pen. Cut out the shapes using a small pair of sharp scissors, and draw in the washing line (you may prefer to mark it in first using the tip of a stylus).

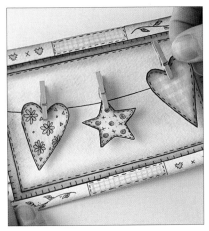

11 Attach the shapes to the washing line using 3D foam pads, and clip on the craft pegs.

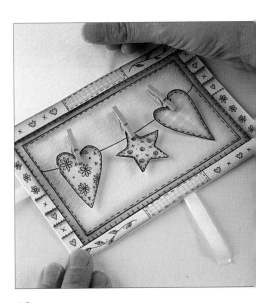

12 Trim the edges of the design, if necessary, to the same size as the card blank, and attach it in the normal way (see page 16).

These cards use raised elements to give a three-dimensional effect and add interest.
On the star card, an extra star has been cut out and attached with 3D foam pads.

A fun mock button has been added to the patchwork star tag (although a real wooden button would also work well).

The pretty butterflies have been cut out neatly from watercolour paper with small, sharp scissors and, once painted, attached to a plain cream card with small 3D foam pads. To decorate the card background, dip the wooden end of a paintbrush into burgundy red paint and dot the paint evenly over the background, keeping the brush upright. An envelope has been painted to match.

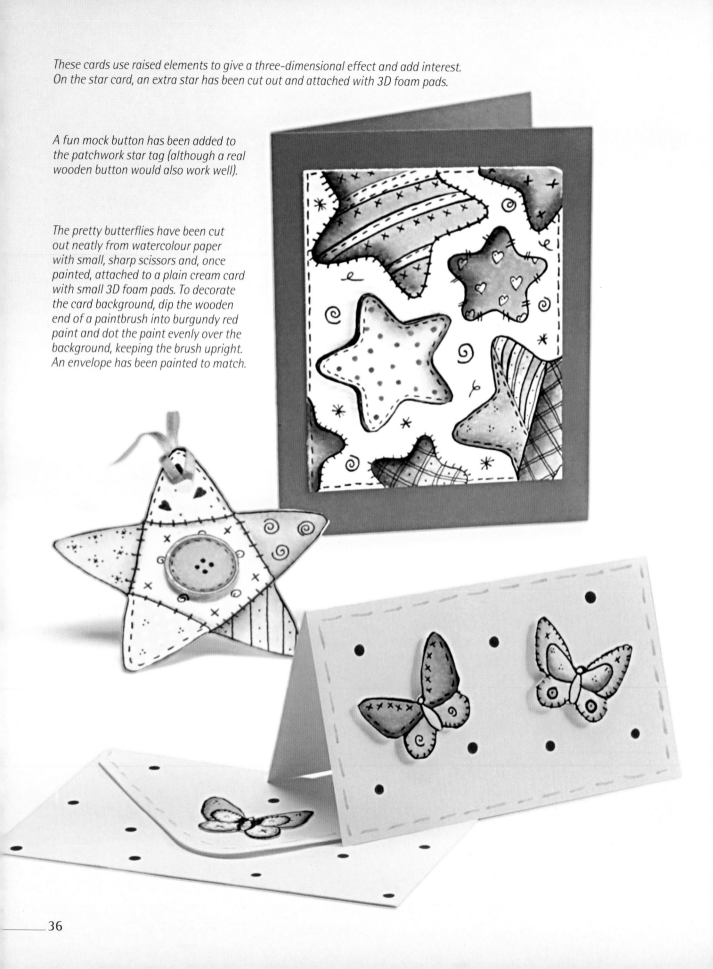

Birdhouses are a favourite of mine as they are such fun to decorate. Paint and add stitching to the three little birdhouses in a row, the two birds and the star before cutting them out and attaching them to the backgrounds.

If the 3D foam pads are too big, use a craft knife to cut them into smaller pieces and then use these to attach the cut-outs to the main card or tag.

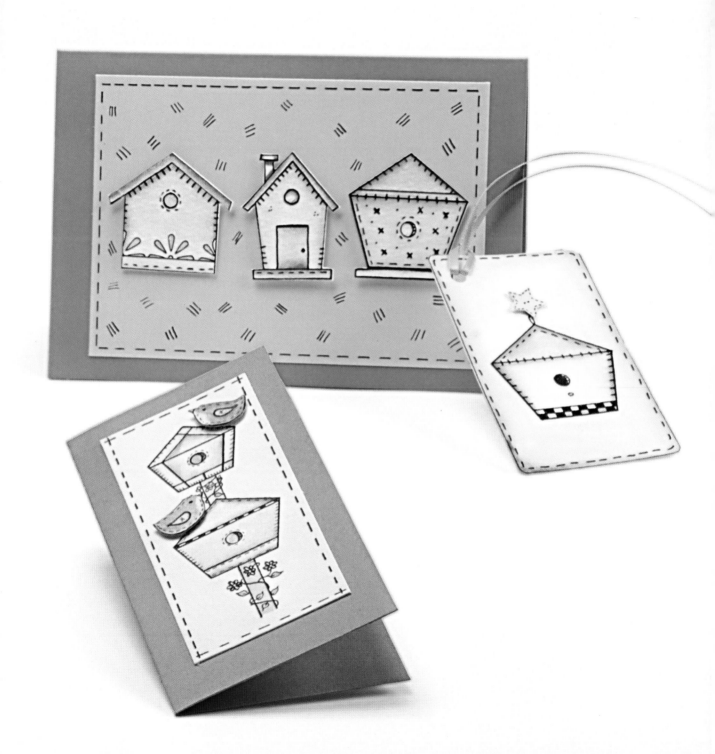

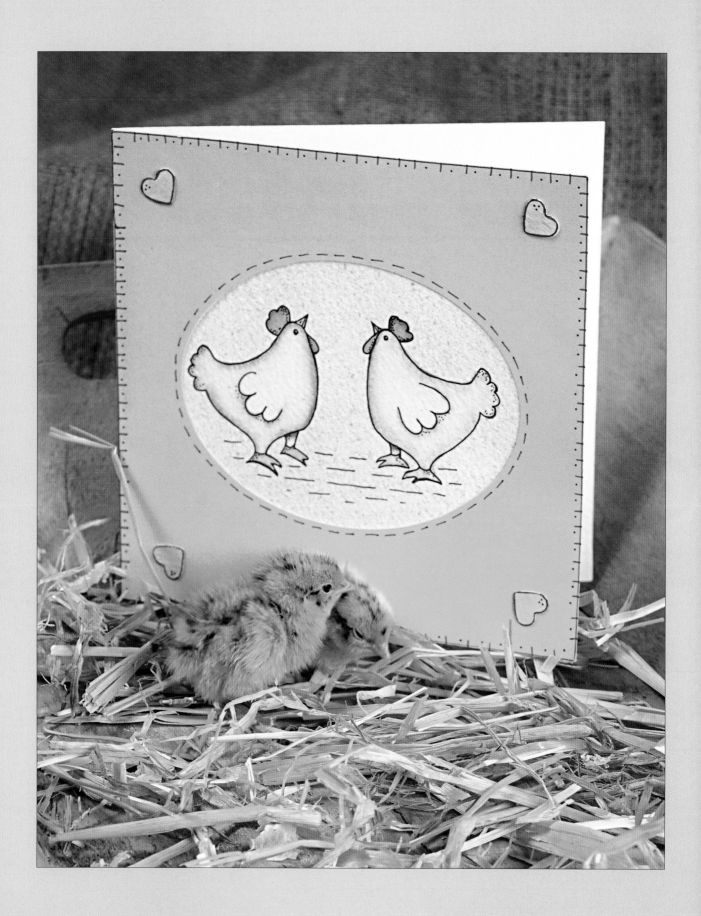

Speckled Hens

This project is a bit of fun, and uses a great little gadget to make a perfect speckled background. The rather fat and cheeky hens are first coated in a layer of masking fluid to protect them during the speckling process, and then brought to life with paint. For this project I chose an aperture card with an oval-shaped opening to represent an egg, and decorated the rest of the card with simple punched-out shapes.

YOU WILL NEED

Acrylic paints: burgundy red, pale yellow and mid-brown

Sizes 2, 4 and 8 round brushes with very fine points

0.5cm (¼in) and 0.25cm (⅛in) angular shading brushes

Old size 4 round paintbrush

Size 02 brown and sizes 01 and 02 black permanent waterproof pens

Watercolour paper, 13.5 x 14.5cm (5¼ x 5¾in)

Orange aperture card, 13.5 x 14.5cm (5¼ x 5¾in)

Masking fluid

Speckling tool or old toothbrush

Heart paper punch

Copy of template and tracing paper

Non-waxed or water-soluble transfer paper and stylus

Daisy dish, ceramic tile, brush basin and pipette

Spare piece of watercolour paper

Paper towel

Metal ruler and eraser

Hairdryer

Cutting mat, craft knife and scissors

Double-sided sticky tape

Mini glue dots and glue stick

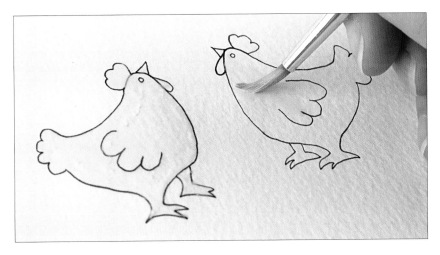

1 Transfer the template to a piece of watercolour paper measuring 13.5 x 14.5cm (5¼ x 5¾in) and dry with a hairdryer. Using an old paintbrush, lay a coat of masking fluid over the chickens, including the outline. Dry as before.

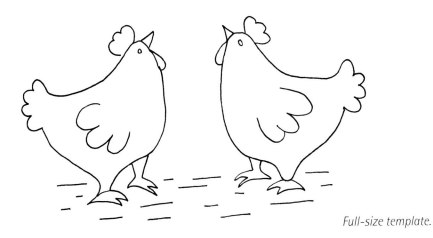

Full-size template.

2 Load the speckling tool with mid-brown paint, and push the pin down into the bristle.

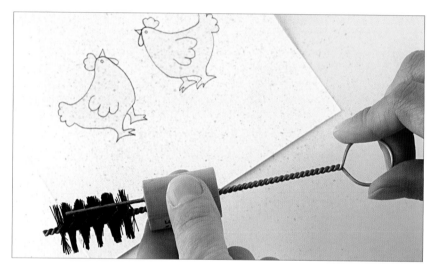

Tip

Practise using the speckling tool on a scrap of paper first. You can load an old toothbrush with paint and flick the bristles for a similar effect.

3 Hold the speckling tool approximately 5cm (2in) above the card, and twist the handle to splatter the card evenly with paint. Rinse out the tool, and repeat the process with burgundy red paint.

4 Dry the background with a hairdryer and remove the masking fluid with an eraser.

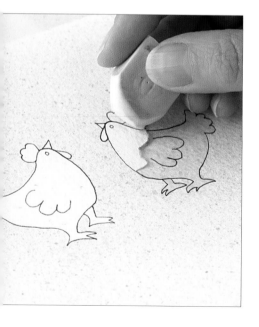

5 Place a pale yellow background wash over both chickens using a size 4 brush, and dry the paint with a hairdryer. Paint in the combs and the wattles using several washes of burgundy red to build up the colour.

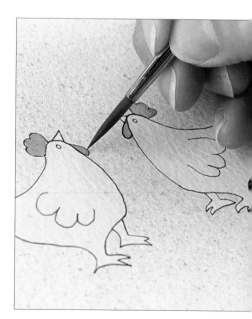

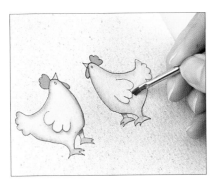

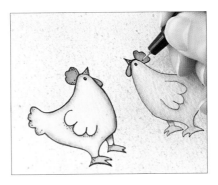

6 Paint in the feet, eyes and beaks using mid-brown, then float a brown border around each chicken, beneath their wings, and at the tops of the legs that are in shadow. Use the small angular shading brush to deepen the red around the top edge of each chicken's comb.

7 Dry the paint using a hairdryer. Strengthen the outlines, including the eyes, add tiny dots for the shadows, and draw in the beaks using a size 01 fine-nibbed black pen.

8 Apply glue using a glue stick around the outside of the aperture, on the inside of the card blank.

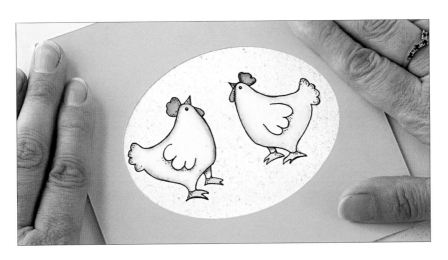

9 Cut out the picture so that it is slightly smaller than the aperture card, and glue it inside the card blank so that the image is positioned centrally in the aperture.

10 Paint a light wash of red over a small piece of watercolour paper and dry. Punch out four small hearts. Draw around the edges of the hearts and add three dots in one corner using a fine-nibbed brown pen. Attach them to the four corners of the card using glue dots. Complete the card by drawing on the brown stitching, and finally the black lines on the ground.

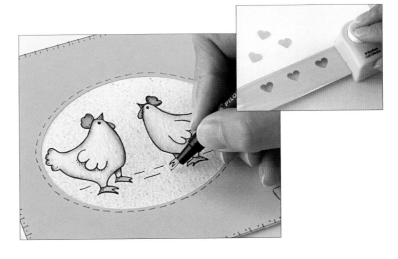

The speckled backgrounds used below work best with simple, uncluttered designs. The dove and snowflake motifs have been transferred on to watercolour paper and filled in with masking fluid. Paint has then been speckled over the surface and allowed to dry before the masking fluid is gently removed with an eraser. Additional elements such as punched flowers and sparkling crystals have been used to add extra interest and dimension.

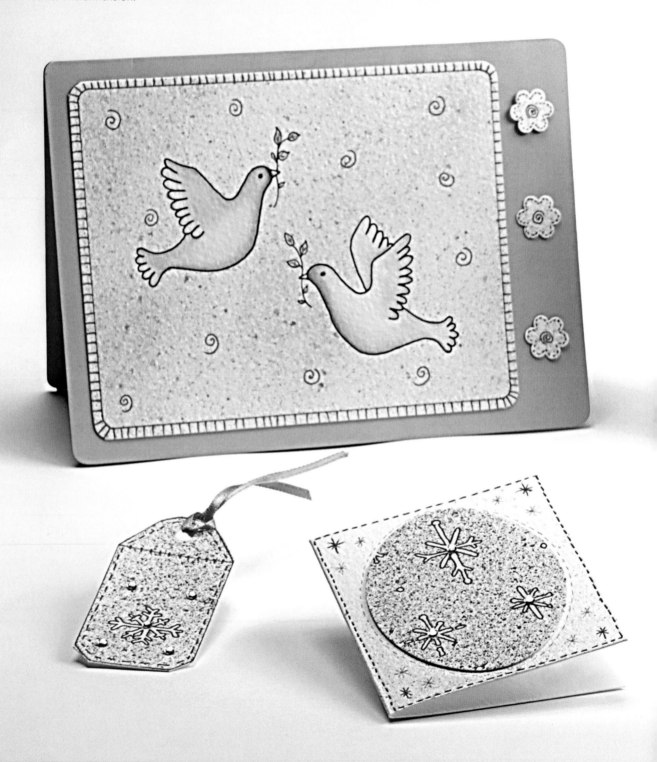

This handsome cat is created in the same way as the other cards, but burgundy red paint is used for the background instead. The design is then trimmed and centred in an oval aperture card.

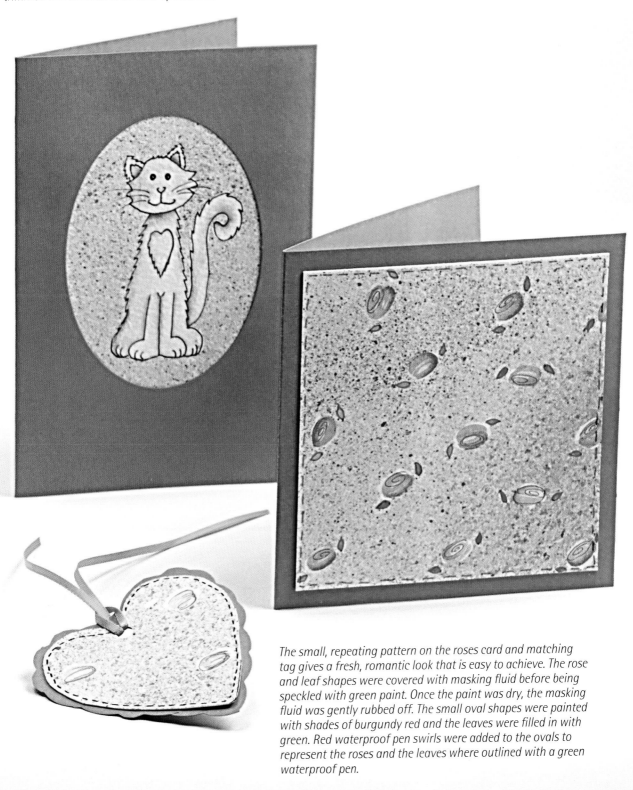

The small, repeating pattern on the roses card and matching tag gives a fresh, romantic look that is easy to achieve. The rose and leaf shapes were covered with masking fluid before being speckled with green paint. Once the paint was dry, the masking fluid was gently rubbed off. The small oval shapes were painted with shades of burgundy red and the leaves were filled in with green. Red waterproof pen swirls were added to the ovals to represent the roses and the leaves where outlined with a green waterproof pen.

Templates for the variations

The templates below are all reproduced two-thirds actual size. To enlarge to the correct size, increase by fifty per cent.

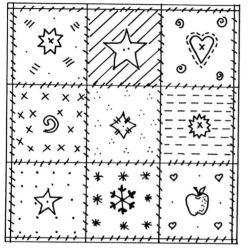

Symbols patchwork card, page 25.

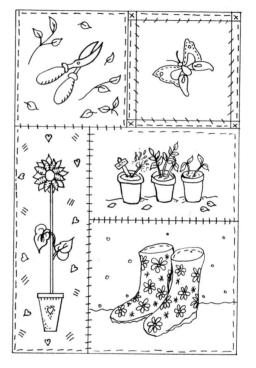

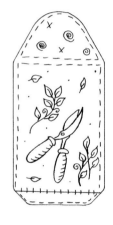

Gardener's delight card and matching patchwork tag, page 25.

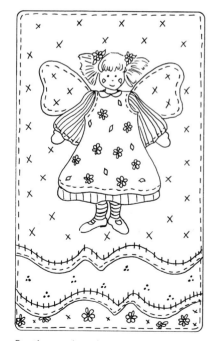

Rustic angel card, page 24.

Patchwork flowers, page 24.

Appliquéd apples tag, page 24.

Birthday celebration card, page 31.

Dragonflies and daisies card, page 30.

Runaway train, page 31.

Flower tag, page 30.

Butterfly tag, page 30.

Butterfly card and matching envelope, page 36.

Star and button tag, page 36.

Silver embossed butterfly card, page 30.

Three little birdhouses card, page 37.

Home tweet home,
page 37.

Birdhouse tag, page 37.

Simply stars card, page 36.

Snowflake card,
page 42.

Doves card, page 42.

Rose card, page 43.

Handsome cat card, page 43.

Snowflake tag, page 42.

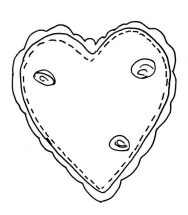

Rose tag, page 43.

Beehive card, page 1.

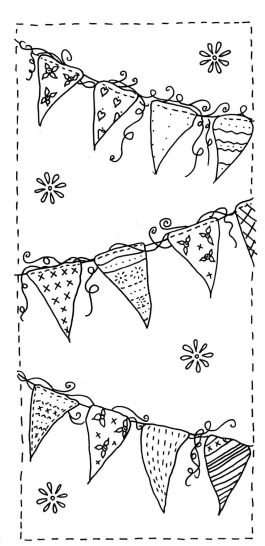

Village bunting card, page 48.

Index

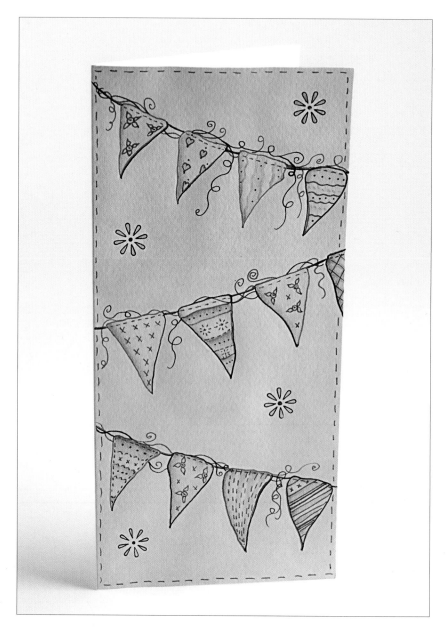

*Village bunting card
(the template is provided
on page 47).*